VERA WANG

Grace Under Pressure-Style, Discipline, and the Making of a Fashion Legend

Maxy M. Max

All rights reserved. No part of this publication may be reproduced, distributed, or transmitted in any form or by any means, including photocopying, recording, or other electronic or mechanical method, without the prior written permission of the publisher, except in the case of brief quotations embodied in critical reviews and certain other noncommercial uses permitted by the copyright law.

Copyright © Maxy M. Max, 2024.

TABLE OF CONTENTS

INTRODUCTION

CHAPTER 1: WHO IS VERA WANG

Early life and background

Transitioning from Skating to Fashion

CHAPTER2: THE FASHION WORLD AWAITS

Internships and the Early Struggles

The Birth of Vera Wang Bridal

From Dream to Reality: Founding Her Own Label

Style, Discipline, and Creativity

CHAPTER 3: THE BUSINESS OF FASHION

Managing Growth and Scaling the Business

The Iconic Bridal Gown

Celebrity Weddings and Their Impact on the Brand

CHAPTER 4: A GLOBAL VISION: VERA WANG'S EXPANSION

Grace Under Pressure

CHAPTER 5: THE VERA WANG AESTHETIC

Fashion and Culture: Vera Wang's Influence

CONCLUSION

INTRODUCTION

In the world of fashion, few names resonate with as much elegance, influence, and innovation as Vera Wang. Known as a pioneer who redefined bridal and evening wear, Wang has become synonymous with modern luxury and sophistication. Yet, her journey to becoming a global fashion icon is not merely a story of success; it is a story of resilience, reinvention, and a relentless pursuit of excellence that has shaped every step of her path.

Vera Wang: Grace Under Pressure – Style, Discipline, and the Making of a Fashion Legend takes readers behind the scenes of her extraordinary life, exploring the forces that molded her character, from her disciplined upbringing in New York to her early years as an elite figure skater with Olympic ambitions. When she shifted her focus to fashion, her deep-rooted dedication drove her to excel in an entirely new arena. From her beginnings as a young editor at Vogue to her role at Ralph Lauren, Wang honed her eye for style and

absorbed the inner workings of the industry, laying the groundwork for what would become one of the most celebrated design careers of her generation.

This book also delves into the artistic and personal values that define Wang's approach to fashion: her respect for beauty and tradition, her love for art and dance, and her daring vision that led her to transform an entire industry. Beyond gowns and couture, Wang's story is about breaking barriers in a competitive field, redefining cultural expectations, and evolving her brand to include ready-to-wear, fragrances, and home design.

As we journey through her milestones, we witness not only Wang's professional achievements but also her resilience in the face of personal challenges and the pressures of success. Grace Under Pressure offers an inspiring look at the life of a woman whose legacy is as much about style as it is about strength, and whose influence in fashion continues to shape how we view beauty and grace. For readers fascinated by fashion, driven by ambition, or inspired by tales of reinvention,

Vera Wang's story stands as a testament to what can be achieved when artistry, discipline, and vision converge.

CHAPTER 1: WHO IS VERA WANG

Vera Wang is a renowned American fashion designer best known for her luxury bridal gowns, evening wear, and contributions to the world of fashion and design. Born on June 27, 1949, in New York City to Chinese immigrant parents, Wang grew up immersed in both Western and Chinese cultures. She initially pursued a career in figure skating and even trained with Olympic aspirations, but eventually shifted her focus to fashion after graduating from Sarah Lawrence College.

Wang began her career as an editor at Vogue, where she worked for 17 years, becoming one of the youngest fashion editors at the magazine. After leaving Vogue, she worked as a design director at Ralph Lauren. In 1990, at age 40, Wang launched her own bridal boutique in New York, where she quickly gained recognition for her sophisticated and modern bridal designs. Her bridal gowns became highly sought after, known for their elegance, luxurious materials, and modern aesthetic.

Since then, Wang has expanded her brand to include ready-to-wear, fragrance, jewelry, and home goods, and her designs have been worn by celebrities on red carpets and brides around the world. Beyond bridal and fashion, she has ventured into numerous collaborations and even created costume designs for figure skaters, including costumes for Olympians like Nancy Kerrigan. Wang's unique blend of elegance and innovation has made her an influential figure in fashion, and her name has become synonymous with timeless luxury and sophistication.

Early life and background

Vera Wang's early life and background reflect a fascinating blend of cultural heritage, artistic influences, and athletic dedication that shaped her into one of the most respected fashion designers in the world. Born on June 27, 1949, in New York City, she was raised in a

privileged and culturally rich environment, influenced by her Chinese heritage and her family's social standing in New York. Her parents, who had emigrated from China to the United States, provided her with an upbringing that balanced traditional values with opportunities in the arts and sports, setting the stage for her eventual career in fashion.

Her father, Cheng Ching Wang, was a successful businessman who owned a pharmaceutical company, and her mother, Florence Wu, was a translator for the United Nations. Her parents' influence instilled in her an appreciation for hard work and dedication. Florence, who had a sophisticated taste in fashion, often took Vera on shopping trips to Paris and introduced her to designers like Balenciaga and Givenchy. These early experiences exposed her to high fashion, inspiring a lifelong appreciation for design and detail that would become central to her career.

Growing up in Manhattan, Vera was educated at Chapin School, an elite all-girls preparatory school, and later

attended The School of American Ballet. The ballet school exposed her to discipline, poise, and the physical demands of performance, all of which would later inform her meticulous approach to design. Ballet also taught her about elegance and beauty, themes she would draw on throughout her career, particularly in her bridal designs, which often reflect a dancer-like grace.

In addition to ballet, Vera Wang was an accomplished figure skater, a passion she pursued seriously from a young age. By the time she was eight years old, she was training intensively in figure skating, a sport that she loved for its combination of athleticism and artistry. She competed in the U.S. Figure Skating Championships and even had Olympic aspirations, training alongside future stars and pushing herself to master the difficult routines and discipline that figure skating required. In 1968, she and her partner competed at the U.S. Figure Skating Championships, though they did not qualify for the Olympics.

While she ultimately didn't pursue figure skating as a professional career, the experience left a profound impact on her. The discipline, determination, and physical grace required in figure skating stayed with her, and the sport's influence is apparent in her later work as a designer. Her designs, particularly in bridal wear, often incorporate elements that evoke the fluidity and elegance of a skater on ice. The athletic discipline she developed during her years in skating helped her approach the demanding world of fashion with resilience and focus.

Wang's academic background also played a role in her journey. After graduating from Chapin, she attended Sarah Lawrence College, where she initially studied art history. She also spent time in Paris at the Sorbonne, which further broadened her exposure to European culture and style. Her studies in art history deepened her appreciation for aesthetics, composition, and historical design, all of which would later influence her approach to fashion. Though her initial plans were not centered on becoming a fashion designer, the cumulative influence of art, dance, and athletics gave her a diverse foundation

that would serve her well when she eventually entered the fashion industry.

In the early stages of her career, Wang faced the challenge of carving out her own path in a highly competitive field. After college, she initially joined Vogue as an assistant and quickly rose through the ranks to become a senior fashion editor. Her years at Vogue gave her unparalleled access to the world of high fashion, where she developed her keen editorial eye, a deep understanding of trends, and connections with influential designers. Working at the magazine for 17 years, she became immersed in the fashion industry's inner workings, studying the art of storytelling through fashion and understanding the business side of the industry. These years at Vogue laid the groundwork for her own creative vision, giving her the experience, industry knowledge, and confidence to eventually launch her brand.

Vera Wang's early life and background are characterized by a unique blend of privilege, discipline, and artistic

exposure. Growing up in a household that valued culture, education, and creativity, Wang developed a love for the arts and a strong work ethic from a young age. Her dedication to figure skating taught her resilience and elegance, while her studies in art history and her work at Vogue allowed her to refine her aesthetic sense and fashion acumen. This combination of influences—from her mother's chic style to her figure skating discipline to her editorial experience at Vogue—set her apart in the fashion world and helped her to develop the distinctive design philosophy that defines her brand today.

Transitioning from Skating to Fashion

Vera Wang's transition from ice skating to fashion is one of the most captivating stories of reinvention in the fashion world. Growing up in a family that valued both culture and achievement, Wang initially set her sights on a career in competitive figure skating. She was

introduced to the sport at a young age and quickly became a talented figure skater, even reaching the level of national contender. Wang's dedication to skating was matched by her discipline and her deep passion for the sport, and for a time, it seemed like her future would revolve around the ice.

However, despite her talent, Vera Wang's competitive skating career never reached the pinnacle she dreamed of. By her early twenties, she realized that, while skating provided her with personal satisfaction and accolades, the intense physical demands and the limited opportunities in the field left her at a crossroads. In her mid-twenties, after years of training and competition, she made the difficult decision to step away from skating and pursue a different path—one that would allow her to channel her creativity and discipline into something new.

It was a challenging shift. Wang was not initially focused on fashion, yet she had always been drawn to the artistry of costumes and aesthetics in skating, which helped bridge her world of sport with the world of fashion. She

enrolled at the prestigious Parsons School of Design in New York City, where she quickly adapted to the fast-paced environment of fashion. Wang's natural eye for style and design, paired with her impeccable taste, made her a standout student. Yet, it was not an immediate transition, and there were struggles along the way. Fashion was a foreign world in many ways compared to the precision of competitive sports, but Wang's dedication and relentless work ethic remained unchanged.

After graduating, Wang began her career at Vogue, working as a fashion editor. Here, she was able to immerse herself in the fashion industry, learning from the best and understanding the intricacies of design, trends, and the business of style. Wang quickly rose through the ranks at the magazine, becoming the youngest senior fashion editor in the history of Vogue, a testament to her natural talent and drive. During her years at Vogue, Wang had the opportunity to work with some of the most influential names in fashion, collaborating with top designers, photographers, and

models, which gave her valuable insights into the mechanics of the fashion world. Yet, despite her success, Wang felt something was missing. Her passion for skating remained, but she recognized that her true creative outlet lay in designing, particularly wedding gowns.

Vera Wang's move into bridal design was not born out of a desire to abandon her skating past but rather a fusion of her lifelong passions for beauty, elegance, and the human form. Her transition was a pivotal moment in her career, marking a shift from the individualism of skating to the deeply emotional and transformative world of bridal fashion. It was a natural evolution for someone with her attention to detail, precision, and desire to create something that would be forever cherished. Wang drew from her experience as a skater, her love of fabric, movement, and artistry, to craft wedding gowns that would become more than just garments—they would become expressions of the bride's personal story, much as skating had once been an extension of her own.

Wang's first breakthrough in bridal design came when she created a custom gown for her own wedding in 1989, a piece that was met with admiration and drew attention from others in the fashion industry. Shortly thereafter, she opened her own bridal boutique in New York City. Wang's designs were different from traditional bridal wear: they were modern, sleek, and infused with a high fashion sensibility that had previously been absent in wedding attire. Her designs were innovative yet timeless, blending luxurious fabrics with clean lines and often pushing the boundaries of what was considered conventional for a bride. Her attention to detail, the quality of her craftsmanship, and her ability to evoke emotion through her creations quickly made her a leading name in bridal fashion.

The transition from skating to fashion might have seemed like a drastic one, but for Vera Wang, it was a natural progression of her creative spirit and passion for aesthetics. Each phase of her life, from skating to fashion, was marked by discipline, an unyielding desire to excel, and a dedication to perfection. Wang's story is

one of resilience, of recognizing the need for change, and of reinventing oneself in the pursuit of new dreams. Her success as a designer is not only a reflection of her immense talent but also of her ability to embrace new possibilities while drawing on the skills and experiences that shaped her earlier years.

CHAPTER 2: THE FASHION WORLD AWAITS

As Vera Wang embarked on her new career in fashion, the path ahead was far from simple. After making the brave decision to leave the world of competitive figure skating behind, she was faced with the daunting challenge of starting over in an entirely different industry. Her transition from ice skates to high heels would not be a quick or easy one, but Wang's meticulous nature, honed through years of discipline in skating, coupled with her innate sense of style, would soon prove to be invaluable in shaping her future in fashion.

Wang began her fashion journey at the renowned Parsons School of Design in New York City, where she immersed herself in the world of design. Though she had no formal background in fashion, her innate creativity and drive were evident from the start. The transition from skating to fashion required a significant adjustment,

particularly in terms of learning the technical aspects of design. While she had always appreciated the artistry of costumes and clothing, the world of haute couture was a different arena altogether, and it would require everything she had learned as a competitive athlete—perseverance, patience, and a sharp eye for detail.

Wang quickly gained recognition for her design abilities at Parsons, where she developed a keen understanding of fabrics, tailoring, and construction techniques. While other students were experimenting with the basics of fashion design, Wang stood out for her precision and natural flair. The same attention to detail that had driven her to excellence in figure skating now manifested in her designs. Fashion wasn't just about creating beautiful garments—it was about perfecting every stitch and seam, ensuring that the design was as flawless as possible. Her time at Parsons provided her with the foundation she needed to make her mark in the fashion industry.

Upon completing her education, Vera Wang's next step was to gain practical experience in the fashion world. She entered the competitive and demanding sphere of fashion magazines, landing a job at Vogue, the most prestigious fashion magazine in the world. She started as a fashion assistant, working long hours and learning from some of the most influential figures in fashion. Wang's talent and dedication didn't go unnoticed, and within a few short years, she earned a promotion to senior fashion editor at Vogue. At the time, she became the youngest person to hold that position, a testament to her remarkable skill and sharp instincts.

At Vogue, Wang's role involved everything from curating photo shoots to styling and collaborating with the industry's top designers. She worked closely with models, photographers, and other creatives, gaining a profound understanding of the fashion world's inner workings. The fast-paced, high-stakes environment of Vogue helped to sharpen her eye for detail and solidified her understanding of what made a design truly exceptional. But even as she thrived in the magazine

world, Wang felt an itch to create something entirely her own—something personal that would allow her to express herself more fully as a designer.

While working at Vogue, Wang began to see an opportunity to innovate within a niche that had been largely overlooked by the high-fashion world: bridal wear. At the time, wedding gowns were primarily traditional, often uninspiring, and not reflective of the modern woman's sensibilities. Wang saw an opportunity to change that, bringing her vision of elegant yet contemporary designs to brides. It was an idea that would forever change the landscape of bridal fashion and firmly establish her as a designer of consequence.

The fashion world was beginning to take notice of Wang's talent, but it wasn't until her personal wedding that her path as a designer truly began to take shape. When she married in 1989, Vera Wang couldn't find a wedding dress that met her expectations. She realized that the wedding industry lacked the kind of sophisticated, high-fashion designs she was accustomed

to seeing in her work at Vogue. Wang decided to design her own gown, and it was a masterpiece—a combination of modern elegance and classic femininity. The dress became a turning point in her career, showcasing her unique design aesthetic and catching the attention of the fashion industry. Shortly after, Wang opened her own bridal boutique in New York City, where she began to offer brides the same kind of couture-quality designs she had always aspired to create.

Her bold foray into bridal fashion was a perfect example of Wang's ability to see untapped potential in a market and fill it with innovation. Bridal gowns at the time were often heavy, traditional, and somewhat uninspired. Wang's designs, in contrast, were sleek, modern, and imbued with a sense of grace that matched her own personal aesthetic. Each gown was a reflection of Wang's commitment to craftsmanship, a dedication to creating something that was not only beautiful but also meaningful.

In the early years, the fashion world may not have fully understood the scope of Vera Wang's vision, but her reputation began to grow quickly. Her designs were not just for the bride—they were a statement. Wang's vision for bridal fashion was one that allowed women to feel confident and beautiful on one of the most important days of their lives, without sacrificing modern sophistication. She was not just designing dresses; she was creating a new bridal identity that was in tune with the needs and desires of the modern woman.

Wang's success came quickly, and with it, the world began to take notice. As her reputation grew, she expanded her offerings, including evening wear, ready-to-wear collections, and even a line of fragrances and accessories. As her business grew, so did her influence on the fashion industry. Wang's ability to merge high-fashion sensibilities with the personal emotional resonance of bridal wear transformed the industry, and she quickly became one of the most celebrated designers in the world. The fashion world that once seemed so distant and overwhelming to her as a

newcomer was now her stage, and Vera Wang had truly arrived.

Internships and the Early Struggles

Vera Wang's early career was defined by a combination of internships, learning experiences, and early struggles, all of which contributed to her eventual rise to the top of the fashion world. While her talent was evident from the beginning, Wang's early years in fashion were marked by a steep learning curve, intense competition, and the determination to build the kind of career she envisioned. Her path was not a linear one, and it required persistence, resilience, and a willingness to push through challenges that many others might have found discouraging.

After completing her education at Parsons School of Design, Wang's first significant step into the fashion industry came through internships. These internships

were essential to her development as a designer, allowing her to gain hands-on experience and exposure to the inner workings of the fashion world. Wang interned at several fashion houses and companies, where she began to understand the technical and creative challenges involved in designing and producing garments. At the time, internships were not just about gaining knowledge; they were about building connections, proving one's work ethic, and making a lasting impression. For Wang, this was a crucial period of her career.

One of her early internships was at the famous fashion magazine Vogue, a place that would later become central to her career. At Vogue, she worked as an assistant to senior editors, which allowed her to observe the mechanics of high-fashion photography, design, and styling. The internship gave her invaluable insights into what made a design truly stand out and what the fashion world was looking for in terms of creativity and innovation. Though Wang had come to Parsons with a strong creative instinct, it was during this internship that

she began to grasp the importance of conceptualizing designs within the context of larger trends and narratives.

But the road was not without its obstacles. As an intern, Wang was just one of many young hopefuls trying to make a name for themselves in an incredibly competitive industry. The fashion world, even back then, was notorious for its demanding nature, and Wang faced a series of early struggles that could have easily deterred someone less determined. The long hours, the low wages, and the challenging environment were all part of the initiation process. Interns were often relegated to the grunt work—running errands, organizing fabrics, and assisting with photo shoots—tasks that could be grueling and repetitive. Yet, Wang approached these early years with the same discipline that had defined her skating career, refusing to let the monotony of the work detract from her goals. She used this time to observe the industry's finest and absorb as much knowledge as she could, even if it meant making sacrifices in the process.

During her internship years, Wang realized the importance of networking and establishing relationships. She understood that a career in fashion was not just about talent but also about the connections one made along the way. Despite the challenges, she started building her network of mentors, designers, and industry insiders who would later become instrumental in her career. She made a point to attend fashion shows, visit galleries, and engage with other creative individuals to learn from them and gain a deeper understanding of the industry's intricacies. The lessons Wang learned during these early internships—about discipline, attention to detail, and networking—would form the bedrock of her future success.

But the real breakthrough came when she transitioned from being an intern to securing a more permanent role in the fashion industry. Vera Wang's first major job was at Vogue, where she worked her way up from assistant to fashion editor. At the time, Vogue was one of the most prestigious fashion magazines in the world, and landing a job there was a major accomplishment for anyone in

the industry. Yet, even with her position at Vogue, Wang's journey was far from easy. As a fashion editor, she had to work incredibly hard to prove herself, constantly competing with other talented individuals for attention and opportunities. She learned how to work under pressure, how to collaborate with photographers and stylists, and how to push creative boundaries while adhering to the magazine's editorial guidelines.

However, despite her successes at Vogue, Vera Wang still felt a sense of dissatisfaction. She was becoming known as a top editor in the fashion world, but her true passion lay in design, not editing or styling. Her time at Vogue taught her much about the fashion industry, but Wang knew she needed to be involved in creating designs rather than simply curating them. She became frustrated with the constraints of her role and felt that she could do more with her own creative vision. It was during this time that she began considering a shift in her career, moving from fashion editing to designing her own pieces.

Leaving Vogue was a significant decision. For many, a role at the magazine would have been the pinnacle of success, but Wang had a broader vision for her future. She transitioned from the world of magazine editing to becoming a designer, but this shift was not without its struggles. The transition from fashion editor to designer meant entering an entirely new field, where she was not only competing against established names but also starting from scratch. Her early designs didn't instantly gain recognition, and her decision to focus on bridal fashion, a niche market at the time, was risky.

Yet, the struggles Wang faced in these early years were integral to her growth as a designer. The challenges she encountered while starting her own bridal label were numerous. She had to establish her brand, find suppliers, and create a collection that would resonate with brides—no small feat, especially for someone still relatively new to the industry. However, Wang's ability to persevere, fueled by the discipline she had learned from her skating days, would prove to be a decisive factor in overcoming the early difficulties.

By continuing to work hard, remain open to learning, and take calculated risks, Vera Wang eventually overcame the early struggles of her career. She built a name for herself in bridal fashion, crafting dresses that broke the traditional mold and resonated with modern women seeking elegance and sophistication on their wedding day. It was through these formative years—internships, early positions, and the challenges that came with starting from the bottom—that Vera Wang was able to refine her skills, develop her voice as a designer, and emerge as one of the most iconic figures in the fashion world.

The Birth of Vera Wang Bridal

The birth of Vera Wang Bridal marked a revolutionary moment in the world of fashion. It was a bold, transformative step that not only launched Vera Wang as a designer but also redefined bridal fashion for

generations to come. At a time when wedding gowns were often traditional, heavy, and uninspired, Wang saw an opportunity to bring something new, fresh, and sophisticated to brides, creating designs that resonated with modern sensibilities while maintaining a timeless elegance.

The inception of Vera Wang Bridal wasn't a spontaneous idea but rather the culmination of Wang's years of experience, both as a figure skater and as a fashion editor. As someone who had a profound understanding of aesthetics, craftsmanship, and the emotional weight of an occasion, she was able to create dresses that felt both personal and celebratory. But it all started with a turning point in Wang's own life—the decision to design her own wedding dress.

In 1989, Vera Wang was preparing to marry Arthur Becker, a businessman who would become her husband. At the time, the wedding industry was dominated by a few traditional bridal designers whose gowns were characterized by classic, often fussy designs. As Wang

went shopping for her own gown, she realized that none of the dresses she saw felt right for her. She wanted a wedding gown that was sophisticated, modern, and graceful but still had the ceremonial weight that a wedding dress should possess. Unfortunately, she couldn't find anything that matched her vision. This frustration planted the seed for what would eventually become her bridal collection. Wang made the decision to design her own wedding dress, and it would become the first of many groundbreaking creations in her career.

Her wedding dress was a striking departure from the usual bridal gowns of the time. Made of silk, it was simple and modern, yet graceful and elegant. The design was sophisticated without being overly ornate, and it featured a flowing, understated silhouette that allowed Wang's natural beauty and poise to take center stage. This dress, which combined both the emotional significance of the event with the practical need for a modern, stylish look, caught the attention of those who saw it. As a result, Wang's decision to design her own gown soon led to requests from family and friends who

wanted dresses made by her as well. It became clear that Wang's understanding of the emotional and aesthetic aspects of bridal fashion was something unique and needed in the industry.

In 1990, Vera Wang officially opened her first bridal boutique in New York City. She set out to create something that was not only about the dress but about an experience—something deeply personal and expressive. The shop was an intimate space, designed to cater to brides seeking something beyond the ordinary. Wang's designs offered a sense of sophistication and modernity that was unmatched by anything else in the bridal market at the time. With a keen eye for what modern women wanted, Wang created dresses that were fashion-forward, unique, and infused with a sense of femininity and romance. These were dresses that empowered women to feel like themselves on their wedding day, rather than conforming to the conventional standards of bridal fashion.

What made Wang's bridal designs so innovative was her ability to blend the technical aspects of dressmaking with a deep understanding of a woman's emotional connection to her wedding gown. She took traditional wedding dress designs and reimagined them—incorporating luxurious fabrics, innovative silhouettes, and unexpected details. For example, she incorporated elements from couture fashion, which was previously unheard of in bridal wear. Wedding gowns that were once stiff and heavy were now light and elegant, with fabrics like silk chiffon and satin flowing effortlessly, creating a soft and flattering effect. Wang's dresses were far from conventional—they were contemporary and chic, capturing a bride's individuality while making her feel like she was wearing something truly special.

Wang's bridal designs also moved away from the typical white dress, offering a wider range of colors such as ivory, blush, and champagne. This allowed for more personalization and gave brides a sense of freedom in choosing a gown that reflected their own tastes,

personality, and wedding theme. Wang was ahead of her time, recognizing that a wedding dress should be an extension of the bride herself, not just a symbol of tradition. Each of her dresses became an opportunity for self-expression, and it wasn't long before brides-to-be from around the world were clamoring to wear one of her creations.

The success of Vera Wang Bridal came not just from her designs, but from the entire experience she offered. She created an atmosphere where brides could feel at ease, knowing that they were working with someone who understood the importance of their wedding day and who could bring their vision to life. This bespoke experience became the hallmark of Vera Wang Bridal and solidified her status as a leading name in the bridal fashion industry.

Over the years, Wang's bridal collections continued to evolve, with new lines and innovations being introduced. Her reputation for creating the most beautiful, couture wedding gowns grew, and celebrities, socialites, and

brides from all walks of life sought her out. Her designs were not only celebrated for their beauty but also for their craftsmanship. Wang's commitment to creating flawless dresses with an eye for detail made her a favorite of many high-profile brides, including famous names like Chelsea Clinton, Ivanka Trump, and Mariah Carey. These high-profile weddings helped elevate Wang's brand and bring her into the global spotlight.

What set Vera Wang Bridal apart from other designers was her commitment to creating dresses that transcended trends. While many bridal designers followed seasonal trends, Wang focused on timelessness. She believed in designing dresses that could be cherished for a lifetime, with quality and design that would never go out of style. This philosophy resonated deeply with her clients, who weren't just looking for a dress—they were seeking a piece of art that would make them feel their absolute best on the most important day of their lives.

The success of Vera Wang Bridal was not just about her technical expertise or design skills—it was about her

understanding of the emotional significance of the wedding dress. Vera Wang was able to combine the art of fashion with the profound emotions associated with weddings, creating designs that made brides feel empowered, beautiful, and confident. The birth of Vera Wang Bridal wasn't just the creation of a new brand—it was the birth of a new era in bridal fashion, one that would continue to inspire generations of brides and designers alike.

From Dream to Reality: Founding Her Own Label

The journey of Vera Wang from an ambitious young woman dreaming of a fashion career to the founder of one of the most iconic and successful fashion labels in the world is a testament to her relentless drive, creativity, and vision. Founding her own label was a bold and calculated move that transformed not only Wang's career but also the fashion industry itself. It was a move that

was not only about creating beautiful designs but about revolutionizing how women experience fashion.

After years of working in the fashion industry, first as a figure skater and then as a fashion editor at Vogue, Vera Wang was well-versed in the nuances of style, luxury, and the inner workings of high fashion. However, despite her accomplishments, there was still a burning desire within her to create something uniquely her own. Wang's career at Vogue and her stint as a designer for other prestigious fashion houses had given her an intimate understanding of what the fashion world demanded, but it also left her feeling confined. She felt she could offer more—something beyond the established norms. This longing for a deeper creative outlet led her to the pivotal moment of leaving her job as a fashion editor and embarking on the journey to establish her own label.

Her decision to branch out on her own was not made lightly. Starting a fashion label in the highly competitive world of New York fashion was a daunting challenge, but Wang had already learned the necessary skills and

gained critical industry knowledge. She had cultivated a deep network of connections, developed her signature eye for design, and accumulated enough experience to understand what was missing in the market. Still, the road ahead was filled with risks, and there was no guarantee of success. She knew she would be competing with established names in the fashion world, and as a newcomer, she would need to carve out her own space and prove that she could offer something unique.

The foundation of Vera Wang's own label began in 1990 when she opened a small bridal boutique in New York. Wang chose to start in the bridal market, an area that was largely traditional and had not seen much innovation or modern design at the time. The wedding industry, especially bridal fashion, had long been dominated by a few major players, and most wedding gowns followed similar patterns—stiff fabrics, voluminous skirts, and lace-heavy designs. Wang's idea was to challenge these conventions and to create gowns that were sophisticated, modern, and elegant—dresses that would not only stand

out but that would feel timeless and personal to the brides who wore them.

She poured everything she had into creating the perfect bridal collection, blending the couture techniques she had honed at Vogue with her natural sense of style and flair. However, establishing a bridal business was no small feat. Wang had to secure suppliers, find the right fabrics, and create a production process. She used her deep understanding of fashion to choose the finest materials and worked with skilled artisans to bring her designs to life. Her first bridal collections were an immediate hit, striking a perfect balance between modern sophistication and the sacredness of the wedding day. Her designs were different from anything that had come before. Vera Wang bridal gowns were sleek, refined, and luxurious, with minimalistic, contemporary silhouettes and the use of sumptuous fabrics like silk and chiffon. This departure from traditional bridal wear gave Wang an edge, and brides, eager for something more fashionable and elegant, quickly flocked to her boutique.

Her success in bridal fashion served as a springboard for expanding her brand into other areas of fashion. The next logical step was to extend her label into eveningwear, ready-to-wear, and even accessories. With each new line, Wang's reputation grew, and her creations became synonymous with luxury, grace, and impeccable craftsmanship. But expanding her label required a combination of savvy business decisions, creativity, and an acute awareness of how fashion trends were shifting. Wang wasn't content to simply replicate what had worked in bridal fashion; she continued to push boundaries, infusing her collections with a sense of innovation that kept her at the forefront of the industry.

However, like any entrepreneur, Wang faced numerous obstacles. The fashion industry is notoriously fickle, and the pressure to stay ahead of trends while maintaining a brand's integrity can be overwhelming. As her label grew, she had to navigate the complexities of building a global brand while staying true to her design philosophy. The challenges of production, financing, marketing, and distribution were constant. But Wang tackled each with

the same determination and discipline that had characterized her career since her days as a figure skater. She surrounded herself with a team that shared her vision and helped guide her brand toward becoming a worldwide symbol of modern elegance and luxury.

Her breakthrough came when her name began to be synonymous with high-profile weddings and celebrities. As her bridal collections gained recognition, the demand for Vera Wang gowns among A-list celebrities grew. Wang designed wedding dresses for public figures such as Mariah Carey, Ivanka Trump, and Chelsea Clinton. These celebrity endorsements not only cemented her reputation in bridal fashion but also propelled her into the broader fashion world. It was clear that Vera Wang wasn't just designing wedding dresses—she was creating a lifestyle and a cultural icon.

Building the Vera Wang brand was not just about creating beautiful dresses; it was about creating an experience. Wang's understanding of her customer—of what a bride wants and needs on one of the most

important days of her life—allowed her to build an intimate connection with those who wore her designs. Her ability to create dresses that made women feel powerful, beautiful, and uniquely themselves became a cornerstone of her label. Vera Wang was more than just a designer; she was an architect of dreams, designing the dress that women would wear when they walked into one of the most important moments of their lives.

The expansion of Vera Wang's label also included a strategic diversification of product lines. Her name was no longer just associated with bridal gowns; she expanded into a range of luxury products, from fragrances to eyewear, from home goods to handbags. This move into lifestyle products was a calculated way to broaden the brand's reach while maintaining the level of prestige and exclusivity that had made her name synonymous with high fashion. As the brand flourished, so did Wang's role as an influential figure in the fashion world. She became a key player in defining modern luxury, bringing together artistry and business acumen in a way that few other designers had managed.

By founding her own label, Vera Wang not only realized her own dreams but also transformed the way women viewed bridal fashion. She shifted the entire narrative around wedding dresses, offering brides not just a gown, but an opportunity for self-expression and elegance. Today, the Vera Wang brand remains one of the most respected names in fashion, synonymous with luxury, innovation, and timeless design. The birth of Vera Wang's label was not just the creation of a brand; it was the birth of a legacy, one that continues to inspire both brides and designers alike.

Style, Discipline, and Creativity

Vera Wang's distinctive approach to fashion is a blend of style, discipline, and creativity, which has set her apart as one of the most influential designers of modern fashion. Her design philosophy is rooted in a deep understanding of both the technical and artistic aspects of fashion,

allowing her to create collections that are not only beautiful but also architecturally precise and impeccably crafted. Wang's ability to balance these seemingly opposing forces—style and discipline, creativity and precision—has allowed her to redefine bridal wear and luxury fashion in a way that is uniquely her own.

Style is at the core of Wang's work, but it is not just about creating visually stunning pieces. Her style is about a deep emotional connection to the woman who wears her designs. It is an expression of elegance, sophistication, and confidence. What distinguishes her style from other designers is her ability to make every piece feel deeply personal. Whether it is a bridal gown, eveningwear, or ready-to-wear collection, Wang's designs are known for their modern, minimalist aesthetic, which allows the personality of the wearer to shine through. She has a unique ability to blend contemporary trends with timeless designs, creating pieces that are not only fashionable but that resonate with women on a personal level. This fusion of tradition

and innovation has made her brand synonymous with luxury and high fashion.

Her commitment to discipline is evident in every aspect of her design process. While many designers rely purely on artistic inspiration, Wang's approach is grounded in a rigorous understanding of fashion construction. She has always been deeply involved in the technical aspects of her work, from choosing the right fabrics to overseeing the production of every garment. This level of attention to detail ensures that her designs are flawless not just in terms of style, but also in terms of fit and structure. Wang's dedication to craftsmanship is seen in the way her gowns are constructed with meticulous precision. Each seam, each stitch, is carefully considered to create a perfect fit and to ensure that the fabric flows in the most flattering way. Her discipline extends beyond the design process, influencing every part of her brand, from the business side to the customer experience. It is this discipline that has allowed her to turn her label into a global force and a symbol of luxury.

Creativity is perhaps the most defining aspect of Wang's work, as she has constantly pushed the boundaries of what is possible within the realm of bridal and high fashion. From the very beginning of her career, Wang sought to create something different from what was already available in the bridal market. At a time when wedding gowns were often traditional and overly ornate, Wang took a bold step forward by embracing modernity. Her gowns were sleek, sophisticated, and simple yet strikingly beautiful. She introduced clean lines, soft silhouettes, and luxurious fabrics, allowing the elegance of the dress to shine through without unnecessary embellishments. Wang's creativity did not stop at aesthetics; it extended to the way she approached design itself. She took risks, incorporating new materials, cutting-edge techniques, and unexpected elements into her collections, always looking for new ways to surprise and delight her clients.

Her creativity is not only evident in her design work but also in the way she has shaped the bridal industry. Before Vera Wang, brides typically wore traditional, often

conservative wedding gowns. Wang changed the narrative by creating dresses that were contemporary, fashion-forward, and empowering. She understood that a wedding dress should reflect the individuality of the bride, rather than conforming to established conventions. Her gowns gave women the freedom to express themselves in a way that was both fashionable and deeply personal. In doing so, Wang revolutionized the bridal market and introduced a new concept of what it meant to be a modern bride. Her creative vision expanded beyond just the gowns themselves; it included the overall experience of a wedding, from the design of the dress to the atmosphere surrounding the event.

What sets Wang apart is her ability to balance style, discipline, and creativity. These three elements are not separate components of her work; rather, they are intertwined, each influencing and elevating the others. Her disciplined approach to design ensures that her creative ideas are brought to life with technical precision, while her strong sense of style ensures that every piece is both beautiful and timeless. Creativity, in

Wang's hands, is not just about coming up with new ideas—it is about reimagining the traditional and elevating the everyday. Her work transcends trends, offering pieces that remain relevant season after season, decade after decade.

Wang's success has been built on her unwavering commitment to these principles. She has always stayed true to her vision of creating designs that make women feel powerful, elegant, and beautiful. Whether it's through the innovative use of fabrics, the precision of tailoring, or the minimalist beauty of her gowns, Vera Wang's work is always characterized by a sense of grace and refinement. The style she has cultivated is elegant and modern, yet it maintains a sense of timelessness that resonates with women from all walks of life. Her discipline has allowed her to build a business that spans far beyond bridal fashion, creating a global brand that stands for luxury and sophistication. And her creativity, constantly evolving and pushing the boundaries of fashion, has cemented her as one of the leading designers in the world today.

In the end, Vera Wang's unique blend of style, discipline, and creativity has set her apart as a designer who doesn't just create clothing, but who creates experiences. Her pieces tell a story, one that is deeply personal to each woman who wears them, and her work continues to inspire both designers and fashion lovers around the world. Whether she is creating a bridal gown, a piece of eveningwear, or expanding into new product lines, Vera Wang remains a symbol of grace under pressure—an enduring force in the fashion world who has built a legacy on the perfect fusion of art and technique.

CHAPTER 3: THE BUSINESS OF FASHION

Vera Wang's success as a designer goes far beyond her unparalleled creativity and craftsmanship; it is also rooted in her shrewd business acumen. Her approach to the business of fashion is as strategic and disciplined as her designs, and her ability to navigate the complexities of running a global fashion empire is one of the key factors behind her remarkable rise to the top of the industry. Wang's ability to blend artistry with entrepreneurship has allowed her to not only build a globally recognized brand but also redefine what it means to be a successful designer in the modern world.

When Vera Wang first ventured into the fashion business by founding her own bridal line, she understood that in order to stand out, she would need more than just a keen eye for design. She recognized that the fashion industry is as much about business as it is about creativity. The most successful designers, she knew, are those who can harness their artistic vision while also understanding

how to operate in a fast-paced, competitive marketplace. Wang quickly grasped that the key to a sustainable career in fashion was building a brand that was not only synonymous with quality and style but also with smart business practices.

One of the first ways Wang built her business was by focusing on a niche market—bridal fashion. The wedding industry, at the time, was largely dominated by traditional designs and old-school conventions. Wang saw an opportunity to disrupt this market by offering a modern, elegant alternative. She created bridal gowns that were sleek, sophisticated, and contemporary, while still maintaining the timelessness that every bride desires for her wedding day. By positioning herself as a designer who could offer something unique and innovative, Wang quickly gained the attention of both brides and the fashion industry at large.

The decision to focus on bridal wear also allowed Wang to establish herself in a market that, while competitive, offered a wealth of opportunities. Wedding gowns are

often seen as a once-in-a-lifetime purchase, and the emotional significance behind them meant that brides were willing to invest in a gown that made them feel truly special. Wang capitalized on this by offering a highly personalized experience for her clients, providing them not just with a dress but with a piece of fashion history. This approach positioned her brand as both luxurious and highly desirable, attracting a high-end clientele.

As her bridal business grew, Wang expanded into other areas of fashion, such as eveningwear, ready-to-wear, and accessories. Her decision to expand was deliberate and strategic. Rather than rushing to diversify her brand, Wang carefully considered how each new product line would complement her existing collections and enhance her brand's identity. Each new venture was a natural extension of her initial success in bridal fashion. Eveningwear, for example, allowed Wang to create glamorous, sophisticated dresses that further emphasized her modern take on luxury, while ready-to-wear garments allowed her to reach a broader audience

without compromising the exclusivity of her bridal designs.

Her business savvy extended beyond simply designing products. Wang was keenly aware of the importance of strategic partnerships and collaborations. From the very beginning, she understood the value of aligning herself with companies that could help elevate her brand and increase her reach. This insight led her to form partnerships with top manufacturers, retailers, and distributors, ensuring that her collections were made available to a global audience. Her ability to navigate the business side of fashion and secure these critical partnerships played a crucial role in transforming her from a successful bridal designer into a global fashion icon.

Another key element of Wang's business success was her understanding of the importance of branding. She meticulously crafted a brand that was not only associated with beautiful, luxurious designs but also with an elevated lifestyle. Vera Wang's name became

synonymous with high-end fashion, and her brand represented sophistication, exclusivity, and timeless elegance. This strong brand identity allowed her to expand beyond just clothing into other luxury products, such as fragrances, eyewear, and home goods. Each new product line reinforced the idea of Vera Wang as a lifestyle brand—one that spoke to consumers who valued quality, design, and the luxury experience.

Wang's keen business instincts also led her to diversify her revenue streams in ways that many designers have not. She embraced collaborations with mass-market retailers, such as her partnership with David's Bridal, which allowed her to reach a broader audience while still maintaining her image as a luxury designer. This careful balance of accessibility and exclusivity helped her capture different segments of the market, from brides on a budget to those seeking the ultimate in high-end luxury. Wang also branched out into the realm of licensing, allowing her to further expand her brand's reach without taking on the complexities of direct production. Licensing agreements allowed her to expand

her product offerings into areas such as shoes, handbags, and jewelry, which in turn fueled further growth for her brand.

Throughout her career, Wang has demonstrated a deep understanding of the evolving nature of the fashion industry. She has adapted to changes in consumer preferences, retail trends, and digital advancements, ensuring that her business remains relevant in an ever-changing landscape. As technology began to play a bigger role in fashion, Wang embraced the use of e-commerce and social media, which allowed her to connect directly with her customers and build an even stronger relationship with them. Wang's presence on platforms like Instagram, where she could share behind-the-scenes glimpses into her design process and showcase her latest collections, helped her maintain a connection with her audience and stay top-of-mind in an increasingly digital world.

What truly sets Wang apart in the business of fashion, however, is her unwavering commitment to maintaining

the integrity of her brand while building its commercial success. She has never compromised on quality or creativity in the pursuit of profit. Her business decisions are always guided by her passion for design and her commitment to delivering the best possible product to her customers. This dedication has not only earned her the respect of her peers in the fashion industry but has also helped her build a loyal and devoted customer base.

Today, Vera Wang is not just a designer but a powerful businesswoman and entrepreneur. She has built an empire that spans across multiple industries, from bridal fashion to luxury goods to lifestyle products. Her ability to balance creativity with business strategy has allowed her to thrive in a notoriously competitive and ever-changing industry. Through her brand, she has redefined luxury fashion and established herself as a leader in the global marketplace. The success of Vera Wang's business is a testament to her talent, her vision, and her unparalleled ability to marry art with entrepreneurship in the world of fashion.

Managing Growth and Scaling the Business

Vera Wang's ability to manage growth and scale her business has been one of the defining factors in her remarkable success. As her brand expanded from a bridal boutique into a global luxury empire, Wang had to navigate the challenges of scaling while maintaining the core values and principles that made her brand so distinctive. Growing a business in the fashion industry is fraught with risks, and yet Wang's strategic approach to scaling her operations has allowed her to maintain her reputation for exceptional design and craftsmanship while reaching new heights of success.

When Vera Wang first launched her bridal line, her vision was clear: she wanted to offer a fresh, modern approach to wedding gowns, catering to brides who desired something elegant and contemporary. At the outset, her business was small, focused mainly on couture bridal fashion. But from the beginning, Wang

understood that in order to succeed, she would need to do more than just design beautiful gowns—she would need to build a sustainable business model that could scale over time. As demand for her designs grew, Wang knew she had to balance creativity with strategic planning in order to meet that demand while retaining control over the quality and integrity of her work.

One of Wang's first steps in scaling her business was securing the right team and infrastructure to support growth. She built a strong core team of talented designers, skilled seamstresses, and expert business professionals who shared her commitment to excellence. Wang's leadership and hands-on approach to managing her team helped foster a collaborative environment where creativity thrived, but where business goals were also prioritized. As the brand grew, she added key hires in sales, marketing, and operations to ensure that every aspect of the business could be scaled effectively. Wang knew that as her brand expanded, it would require more sophisticated systems and processes to maintain the

same level of attention to detail and quality that had made her initial designs so sought after.

In addition to her internal team, Wang was savvy in selecting the right external partners to support the growth of her business. Early on, she formed strategic partnerships with manufacturers, retailers, and distributors to expand her reach without compromising the brand's high-end status. These partnerships were key in helping her grow her business beyond the niche bridal market. For example, Wang worked with luxury department stores like Neiman Marcus and Saks Fifth Avenue to ensure that her designs were available to a wider audience while maintaining exclusivity. She also expanded her product range to include eveningwear, ready-to-wear, and accessories, which allowed her to tap into new markets and diversify her revenue streams.

A critical aspect of scaling any business is managing production, and Vera Wang's attention to detail in this area ensured that her designs maintained the same level of quality as her business grew. Initially, Wang was

deeply involved in every step of the production process, but as her brand scaled, she had to delegate more of these responsibilities. However, she remained highly engaged in overseeing production standards, working closely with suppliers and manufacturers to ensure that each piece met her exacting standards. Wang's commitment to quality control was one of the reasons why her brand could expand without sacrificing the craftsmanship that was integral to her identity as a designer. She was also proactive in embracing technology to streamline production processes, allowing her to manage larger volumes of orders without compromising the creative vision of her collections.

Expanding internationally was another key challenge in managing the growth of Vera Wang's business. As her brand became more recognizable, there was increasing demand for her designs from customers around the world. Wang's ability to scale globally without losing touch with her brand's essence is one of the reasons why she has enjoyed sustained success. Rather than simply licensing her name to international retailers, Wang took a

more hands-on approach to international expansion, carefully selecting the right partners in each market to preserve the integrity of her brand. She opened flagship stores in key cities like New York, London, and Tokyo, where she could maintain direct control over the presentation of her collections and the customer experience.

Her international expansion strategy was also centered around understanding local markets. Wang made sure that her collections resonated with the tastes and preferences of brides and fashion-conscious women in different regions. For example, while her signature bridal designs were characterized by clean lines and modern sensibilities, she adapted certain elements of her collections to meet cultural expectations, offering a diverse range of styles that appealed to various international tastes. This adaptability was essential to her success in scaling her business to a global level.

As Vera Wang's brand grew, she was also mindful of the importance of diversifying her revenue streams. One of

the key decisions she made was to enter the world of licensing. Licensing allowed Wang to expand her product offerings—into categories such as fragrances, eyewear, and home goods—without having to manage the complexities of direct production. This decision enabled her to tap into new markets and broaden her customer base while maintaining the luxury perception of her brand. Wang was also savvy in licensing her name for products that complemented her core bridal and fashion business, ensuring that each new category reflected her brand's core values of elegance and sophistication.

Managing the growth of her business also meant adapting to changing retail trends. As e-commerce grew in importance, Wang recognized the need to embrace the digital world and ensure that her brand was represented online. She developed a robust online presence, with a strong social media strategy that allowed her to connect directly with her customers. This direct engagement with her audience helped her strengthen her brand's relationship with consumers, creating a sense of loyalty

and community around her designs. Wang also recognized the growing importance of the millennial and Gen Z demographic, and as a result, she adjusted her marketing and product strategies to appeal to younger, more tech-savvy consumers who valued both luxury and accessibility.

The challenge of scaling a fashion business is not just about increasing production or opening new stores; it's about maintaining the values that make a brand unique. Vera Wang has been able to grow her business without losing sight of the artistry, craftsmanship, and luxury that have always defined her work. She carefully managed the expansion of her brand, ensuring that each new product line, each new market, and each new partnership aligned with her core vision. Wang's ability to scale her business successfully has allowed her to build a legacy as one of the most influential and enduring designers of her generation. Her story is a testament to the fact that growth in the fashion industry is not just about numbers—it's about maintaining the authenticity of the

brand while adapting to meet the needs of a changing world.

The Iconic Bridal Gown

Vera Wang's iconic bridal gown has become synonymous with sophistication, elegance, and modernity. From the very beginning of her career, Wang sought to create wedding dresses that were not just garments but profound expressions of a bride's personal style and dreams. Her bridal designs have redefined the concept of what a wedding gown could be, transforming the industry with their innovative approach to form, fabric, and function. Vera Wang's gowns are no longer simply dresses for brides—they are symbols of a new era in bridal fashion.

Wang's influence on bridal wear began in 1990 when she launched her own bridal collection at a time when traditional wedding dresses were characterized by stiff,

formal silhouettes and heavy embellishments. Wang, who had a deep appreciation for fashion's artistry, envisioned a bridal gown that was fluid, feminine, and modern—something that a bride could truly feel herself in on one of the most important days of her life. By blending traditional elements of wedding gowns with a contemporary sensibility, she created dresses that were romantic but also forward-thinking. Her approach was groundbreaking in its simplicity: she rejected the overly ornate styles of the past and embraced clean lines, luxurious fabrics, and understated embellishments.

The turning point for Vera Wang came when she designed her first collection of bridal gowns in 1990, blending her vision with her understanding of fashion trends. She sought to offer brides something new, a design ethos that moved away from the classic, cookie-cutter approach to wedding fashion. Wang made the bold decision to move beyond the traditional white gown, introducing ivory, champagne, and other softer hues to the bridal palette. This was a reflection of her desire to allow brides to express themselves as

individuals rather than adhere to outdated conventions. Her innovative use of color was one of the first steps in redefining bridal fashion, and it signaled the beginning of a new era for wedding gowns.

The hallmark of Vera Wang's bridal collections is her masterful use of luxurious fabrics. She is known for working with the finest silks, taffetas, and organzas, which lend her gowns a weightless and ethereal quality. These fabrics, carefully chosen for their texture and flow, create movement within the dresses, allowing them to reflect the bride's every gesture with grace and elegance. Wang's keen eye for fabric design and texture allows her to play with contrasts in her gowns—combining soft, flowing layers with structured bodices, or mixing matte materials with glistening details like Swarovski crystals or delicate lace.

But it's not just the fabric that defines Wang's iconic gowns—it's the way she constructs them. Each piece is a testament to her skill as a designer and her attention to detail. Vera Wang's gowns are known for their sculptural

quality; the way they hug the body in just the right places and flare out with a sense of ease. She masterfully combines structure with softness, creating a silhouette that is both flattering and comfortable for the bride. Whether it's a ball gown with a voluminous skirt or a sleek, fitted dress with a high-low hem, Wang's designs emphasize the beauty of the female form while providing a sense of movement and fluidity that allows the bride to feel free.

Wang's gowns also distinguish themselves through their subtle but striking embellishments. While she has always preferred a minimalist approach to decoration, she is known for using intricate, delicate touches that make each gown unique. From hand-stitched lace to beaded appliqué, the embellishments in Vera Wang's bridal gowns are always thoughtfully placed, never overwhelming the overall design. She has a particular affinity for using floral motifs, which appear in various forms throughout her collections, from embroidered lace flowers to cascading silk blooms. These details add

depth and texture to the gown, giving it a sense of individuality without detracting from its timeless beauty.

One of the most significant innovations that Vera Wang brought to the bridal world is her commitment to creating wedding dresses that feel like works of art—gowns that women would want to wear long after their wedding day. The designs are timeless, yes, but they are also made with an understanding of the bride as a person. Vera Wang's creations are meant to make a statement, but they also aim to reflect a bride's inner beauty and personality. Many of her gowns feature delicate draping or asymmetrical elements that create a sense of movement, echoing the energy and emotions of the day itself. These gowns are not just about looking beautiful; they are about telling a story, about being a part of a life-changing moment.

Wang's bridal gowns have also helped define what modern femininity looks like. The traditional wedding dress often implied a sense of fragility or submission, but Vera Wang's gowns are empowering. They embrace the

bride's individuality, her strength, and her sense of self. Many of her designs feature a contemporary twist on traditional elements, such as a strapless bodice or an off-the-shoulder neckline, offering brides the freedom to showcase their personalities and bodies in a way that feels authentic. These gowns exude confidence, providing brides with a sense of self-assurance on one of the most emotional and significant days of their lives.

Perhaps what truly sets Vera Wang apart in the bridal world is her ability to anticipate and set trends. Her designs are both modern and timeless, always pushing the boundaries of what a wedding gown can be. When other designers were still focused on traditional bridal silhouettes, Wang introduced innovative elements like short skirts, color accents, and even pantsuits, allowing brides to choose their own paths. Her willingness to take risks has paid off, as her collections have consistently been met with critical acclaim and commercial success. Wang has become the designer of choice for high-profile brides, from celebrities to socialites, who see her gowns

as more than just clothing—they see them as works of art that symbolize their unique love stories.

The lasting appeal of Vera Wang's bridal gowns lies in their ability to evolve with the times while retaining the essential qualities that have always defined her work. Each new collection builds upon the previous one, introducing new ideas, techniques, and inspirations, but always staying true to the brand's core principles of elegance, modernity, and femininity. Vera Wang's wedding gowns remain some of the most sought-after designs in the world, and her ability to create dresses that are as iconic as they are timeless has secured her place in history as one of the greatest bridal designers of all time.

Celebrity Weddings and Their Impact on the Brand

Vera Wang's association with high-profile celebrity weddings has played a significant role in cementing her

status as one of the most iconic bridal designers in the world. The allure of a Vera Wang gown, seen on some of the most famous brides in history, has elevated the brand to new heights, transforming it from a boutique bridal line to a global powerhouse. The influence of celebrity weddings on her brand cannot be overstated, as these high-profile moments have shaped public perception of the Vera Wang name and reinforced its image as synonymous with luxury, elegance, and sophistication.

Wang's first major brush with the world of celebrity came in the early 1990s when she designed the wedding gown for actress and fashion icon, Ivanka Trump, for her wedding to Jared Kushner. This high-profile wedding, which took place at the Trump National Golf Club in Bedminster, New Jersey, captured the attention of media outlets worldwide. The ivory silk gown that Wang designed for Ivanka Trump was both classic and contemporary, a perfect reflection of Wang's signature style. The gown featured a voluminous skirt, intricate beading, and a delicate train, which helped set a precedent for Vera Wang gowns as being sophisticated

yet youthful. This wedding, along with the visibility it garnered, placed Vera Wang firmly in the spotlight and attracted a new, affluent clientele who were eager to wear the designer's creations on their own big days.

As the years went by, Vera Wang's celebrity clientele grew, with famous names like Kim Kardashian, Khloé Kardashian, Chelsea Clinton, and Victoria Beckham turning to her for their wedding dresses. These high-profile brides were not just looking for a wedding gown—they were seeking a statement piece that represented their personal style and social status. For Vera Wang, designing for celebrities was not just about dressing the rich and famous; it was about curating a narrative that would resonate with brides around the world. Every gown she created for her celebrity clients told a story and added to the larger-than-life image of the Vera Wang brand.

The wedding of Kim Kardashian to basketball star Kris Humphries in 2011 was a pivotal moment for Vera Wang's brand. Although the marriage was short-lived,

the wedding itself was nothing short of spectacular. Kim Kardashian wore a custom Vera Wang gown that was nothing like traditional bridal wear—its sleek, modern design was inspired by Wang's signature blend of contemporary and classic elements. The gown, featuring layers of silk tulle and a fitted bodice with a dramatic train, made headlines and was widely covered by the media. The high visibility of Kardashian's wedding, paired with the fact that she wore a Vera Wang gown, created a ripple effect in the fashion world. It solidified Vera Wang as the designer of choice for modern brides who sought a balance of tradition and innovation. The association with a global figure like Kardashian brought new attention to Wang's brand, making it more accessible to a broader demographic while still retaining its aura of exclusivity.

The influence of celebrity weddings on Vera Wang was not just about the gowns themselves but also the broader cultural phenomenon surrounding celebrity marriages. Wang's gowns have become symbolic of success, glamour, and a certain level of opulence. Brides seeking

a Vera Wang gown are not just looking for a dress—they are seeking a symbol of status, a statement piece that reflects their aspirations. This has made Wang's designs incredibly aspirational, as her dresses have come to represent the pinnacle of bridal fashion. For many women, wearing a Vera Wang gown is seen as an opportunity to embody the elegance and beauty of the celebrities they admire.

In addition to the Kardashian wedding, other notable celebrity brides in Vera Wang gowns include Chelsea Clinton, who wore a dress by Wang for her wedding to Marc Mezvinsky in 2010. Clinton's wedding gown, a timeless, graceful creation with a strapless, a-line silhouette, was a departure from the more modern designs Vera Wang was known for but showcased her versatility as a designer. The gown was elegant and understated, yet still reflective of the sophistication that Vera Wang is known for. The wedding, which was watched by millions and covered extensively in the media, only served to solidify Vera Wang's reputation as

the designer for brides who wanted to make a memorable impact on their big day.

Wang's celebrity clientele also includes actresses such as Anne Hathaway, who chose Vera Wang for her wedding to Adam Shulman in 2012. Hathaway's choice of a custom-designed Vera Wang gown, which featured delicate lace and a soft A-line silhouette, underscored Wang's ability to bring a sense of romance and modern elegance to her designs. The gown was widely praised for its delicate beauty and classic appeal, further cementing Vera Wang's position as the designer of choice for stars looking to make a lasting statement. The visibility that these high-profile weddings provided helped propel Vera Wang's name even further into the mainstream.

The impact of celebrity weddings on Vera Wang's brand is not limited to the designers' gowns themselves but extends to the marketing power they bring. Celebrity weddings are often broadcast to millions of people through media outlets, and Vera Wang's name has

become synonymous with these iconic moments. The wide media coverage that surrounds celebrity weddings—particularly when the bride wears a Vera Wang gown—has a ripple effect, reaching beyond the immediate wedding audience to broader demographics. Bridal magazines, fashion websites, and social media platforms all contribute to the amplification of these high-profile weddings, and in turn, they shine a light on Vera Wang as the go-to designer for brides seeking luxury, exclusivity, and an unforgettable dress.

As more celebrities have chosen Vera Wang for their weddings, the designer's brand has evolved to encompass more than just bridal fashion. Vera Wang has expanded her offerings, creating bridesmaid dresses, evening wear, and even a collection of fragrances, each of which bears the same sense of refinement and timeless beauty that she's known for in bridal fashion. Her celebrity clientele has helped transform the perception of her brand from a luxury label into a cultural symbol of elegance and taste. Vera Wang is no

longer just a designer; she is a symbol of aspirational beauty and sophisticated style.

Celebrity weddings also gave Vera Wang the opportunity to engage with the bridal market in a more personal way, building deeper relationships with her clients and providing them with more tailored experiences. Brides are drawn to Vera Wang not only because of the designer's legacy but because they know that the gown they are wearing has been chosen by countless celebrities before them. This connection to the world of celebrities helps brides feel as though they are part of something bigger, something exclusive. It's no surprise, then, that Vera Wang gowns have been a go-to for brides who want to feel as special and celebrated as the celebrities they admire.

Vera Wang's celebrity weddings have had a lasting impact on the brand, shaping its image as one of the most iconic bridal labels in the world. Through her association with some of the most famous weddings in modern history, Wang has elevated the wedding dress to

an art form—one that is not only about fashion but about creating lasting memories. These high-profile weddings have solidified her position as a designer whose creations are more than just dresses; they are symbolic of dreams, aspirations, and the magic of love itself.

CHAPTER 4: A GLOBAL VISION: VERA WANG'S EXPANSION

Vera Wang's global expansion has been a defining aspect of her brand's trajectory, transforming it from a boutique bridal label into an international empire. Her vision for Vera Wang has always been more than just creating beautiful bridal gowns; it's been about crafting a lifestyle brand that resonates with women around the world, offering not only high-fashion wedding dresses but also a broader range of luxury products that speak to her design philosophy. From her initial focus on bridal wear to the creation of a diverse array of offerings, Vera Wang's global expansion reflects her ability to adapt to market demands while maintaining the elegance and sophistication that have become her trademark.

The foundation of Vera Wang's global success lies in her strategic expansion into international markets. From the early days, when she designed exclusive gowns for

high-profile clients in the United States, Wang's ability to cater to affluent brides has translated seamlessly into global markets. Vera Wang first ventured internationally by opening stores in major cities like London, Tokyo, and Hong Kong, each location a carefully chosen hub for the brand's international audience. These flagship stores were designed not just as retail outlets but as immersive spaces that embodied the essence of Vera Wang's luxurious and timeless aesthetic. For Wang, these international boutiques were not just about expanding her brand—they were about offering brides a global experience of luxury and exclusivity.

The move to international retail was also bolstered by the strategic partnerships Vera Wang entered into with various luxury retailers and distributors. These partnerships allowed her to introduce her products to a wider audience, from bridal gowns to evening wear and accessories. For example, her collaboration with Kohl's in 2007 marked a significant shift in her brand's accessibility. This partnership, which offered a more affordable range of products, allowed Wang to tap into a

broader consumer base while maintaining her high-end bridal reputation. The Kohl's collaboration, though distinct from her high-fashion designs, played a vital role in positioning Vera Wang as a designer who could cater to different segments of the market, from the affluent bride to the more budget-conscious shopper looking for a touch of Vera Wang elegance.

In addition to her expansion in retail, Vera Wang's foray into licensing agreements helped her gain a foothold in markets beyond fashion. Licensing her name and designs to produce everything from fragrance to home décor has been a brilliant way to ensure that Vera Wang's brand extends far beyond the wedding aisle. The launch of Vera Wang's first fragrance in 2002 was a pivotal moment in this expansion. The perfume, a sophisticated and feminine scent, was an instant success, leading to the creation of a range of fragrances that mirrored the designer's signature style. The fragrance line became an important revenue stream, reinforcing her status as a brand that encapsulated luxury and refinement in every aspect of a woman's life.

Her vision also extended into the world of accessories, where she designed jewelry, handbags, and shoes that complemented her bridal and evening wear collections. Vera Wang's accessories became integral to the complete bridal experience, offering brides everything they needed to achieve a cohesive look. The Vera Wang bridal collection, which originally focused solely on wedding dresses, now includes an extensive range of products that span multiple categories, including bridesmaids' dresses, evening wear, shoes, jewelry, and home items. Each of these new lines has been crafted with the same attention to detail and design excellence that has made Vera Wang synonymous with bridal fashion. The expansion into these new product categories has allowed Wang to maintain her relevance in a competitive marketplace while offering brides a one-stop-shop for their wedding needs.

Vera Wang's global expansion is also reflected in the brand's ability to cater to various cultures and tastes. While her designs are grounded in Western fashion

traditions, Wang has always been attuned to the diverse needs of brides around the world. Her collections are often adapted to meet the specific cultural preferences and expectations of brides in different countries. For instance, the preferences for wedding dresses can vary dramatically in countries like China or India, where color, embellishment, and design aesthetics may differ from the traditional Western white gown. Vera Wang's ability to create collections that appeal to these diverse tastes without compromising her design integrity is a testament to her deep understanding of the global bridal market.

The success of Vera Wang's global expansion also lies in her brand's ability to innovate and stay ahead of trends. As the bridal industry has evolved, so too has Vera Wang's vision. She has consistently pushed the boundaries of bridal fashion, introducing modern designs that challenge traditional expectations. Her willingness to embrace innovation is part of what has made her such a global force in the fashion industry. Wang's designs are known for their contemporary twist on classic bridal

gowns, often incorporating unusual fabrics, unexpected color palettes, and avant-garde silhouettes. This willingness to break from tradition while still offering elegant, timeless pieces has resonated with brides seeking something more unique and personal.

Beyond the retail and product licensing expansions, Vera Wang's influence in the fashion world has grown through collaborations with other designers and brands. These collaborations have not only broadened her reach but have also reinforced her position as an innovator in the luxury fashion world. Vera Wang's collaborations with companies such as Zales for fine jewelry, and her partnerships in the fashion and lifestyle sectors, have given her access to new consumer markets while helping to build her brand's prestige.

Her global expansion efforts have also been aided by her keen understanding of the power of media and digital presence. As social media became an increasingly important marketing tool, Vera Wang harnessed the power of platforms like Instagram and Pinterest to

showcase her designs to a wider audience. The visibility that social media provides has helped Wang engage directly with brides-to-be around the world, allowing them to share their wedding experiences and Vera Wang designs with their followers. This digital engagement has played a critical role in maintaining the brand's relevance in a constantly evolving marketplace.

Vera Wang's ability to balance luxury with accessibility, innovation with tradition, and exclusivity with mass appeal has been key to her successful global expansion. Her brand is now not just about wedding gowns but about creating a lifestyle of sophistication and elegance that transcends any one product category. Vera Wang's designs are worn not only by brides but by women who wish to embody the refined, timeless aesthetic she has crafted over decades. From bridal wear to fragrances, jewelry, and home décor, Vera Wang has created a brand that is synonymous with luxury and style, offering women around the world the opportunity to embrace the elegance of Vera Wang in every aspect of their lives.

Through her strategic international expansion, Vera Wang has become a global fashion icon, revered for her ability to blend tradition with modernity, create universally appealing designs, and maintain a sense of exclusivity while reaching new markets. The success of Vera Wang's expansion is a testament to her visionary leadership, her understanding of consumer desires, and her tireless commitment to crafting beautiful, unforgettable designs that resonate across cultures and generations.

Grace Under Pressure

Vera Wang's ability to maintain grace under pressure has been a defining characteristic of her career and a key factor in her success. The fashion industry is notoriously competitive, demanding, and often unforgiving, yet Wang has consistently demonstrated an extraordinary poise in navigating the challenges that come with being a designer at the top of her field. Whether facing tight

deadlines, managing the high expectations of her clients, or dealing with the intricacies of running a global brand, Wang's calm, disciplined approach has allowed her to not only survive but thrive in such a dynamic and high-pressure environment.

From the early days of her career, Wang learned to handle the pressures of the fashion world. As a figure skater transitioning to fashion design, she was no stranger to performance anxiety and the intense scrutiny that comes with any public-facing profession. In figure skating, every move was observed by an audience, and every competition was a test of personal resilience. The lessons she learned from her years on the ice—how to perform under pressure, stay composed, and focus on the task at hand—translated seamlessly into her design career. As she moved from skating into fashion, she quickly realized that the stakes in design were equally high, requiring not only technical expertise but also an ability to balance creativity with practicality under intense pressure.

Managing the pressure of the fashion industry involves a delicate dance of maintaining one's artistic vision while responding to the realities of the marketplace. For Wang, this balancing act required constant negotiation between her desire to push the boundaries of bridal fashion and the demands of clients who often sought traditional designs. When she launched her first bridal collection, the stakes were immense. She had no established reputation in the bridal world and was stepping into a competitive market where brides were looking for gowns that were both unique and timeless. Wang's ability to stay calm and focused during this pivotal moment allowed her to create designs that set her apart from other designers. Rather than succumbing to the pressure to conform to traditional bridal styles, she took the bold step of offering gowns that combined elegance with a contemporary flair, a move that would come to define her brand.

The pressure didn't ease as Wang's brand grew and her reputation solidified. As her company expanded into new product categories and international markets, the scope

of her responsibilities increased exponentially. Running a global brand requires a high level of organization, vision, and strategic thinking, but it also involves dealing with constant pressure from multiple sources. Financial pressures, logistics, creative demands, and client expectations all converge, and for many in the fashion industry, this can be a source of stress and burnout. However, Wang's ability to handle this pressure with grace and poise has been crucial to her success. She has managed to keep her designs fresh and relevant, all while balancing the demands of running a luxury fashion business.

One of the key elements that has enabled Wang to maintain her composure is her discipline. Over the years, she has cultivated a rigorous work ethic that allows her to manage the numerous challenges she faces without being overwhelmed. For Wang, discipline is not just about working hard; it is about working smart. She is known for her meticulous attention to detail, from the design process to the production of her gowns. This level of discipline extends to every aspect of her business,

whether it is overseeing her creative team or ensuring that each gown meets her high standards of craftsmanship. Her disciplined approach helps her manage the complexities of running a business with grace, allowing her to remain focused on her goals despite the many pressures she faces.

In addition to her discipline, Wang's ability to stay calm and composed in the face of external pressures can be attributed to her strong sense of self and a clear vision of her brand. Early in her career, she was advised to adopt a more commercial approach, to design what the market wanted rather than what she personally believed in. However, Wang held steadfast to her vision, trusting that her artistic instincts and commitment to quality would ultimately lead to success. This confidence in her own abilities and vision allowed her to take risks, whether in terms of the designs she created or the business strategies she pursued, without being consumed by fear of failure or rejection. Her ability to maintain this self-assurance in the face of external criticism and pressure has been instrumental in her long-term success.

Wang's grace under pressure has also been evident in her ability to navigate the personal and emotional challenges that come with being a public figure in the fashion world. As the designer for some of the most high-profile weddings, Wang has been thrust into the spotlight many times, and each time she has maintained an air of professionalism and elegance. Her ability to manage relationships with celebrities, clients, and collaborators, while keeping her focus on the work, demonstrates the quiet strength that has propelled her forward. She has faced personal challenges as well, including the loss of her father, and she has shown incredible resilience, continuing to run her business and create her designs with an unwavering sense of purpose.

At the same time, Wang's grace under pressure is also reflected in her leadership style. As a businesswoman, she has built a team around her that shares her values of creativity, excellence, and collaboration. Wang is known for fostering an environment where innovation and creativity are encouraged, but she also understands the

importance of keeping things grounded and efficient. She doesn't shy away from making tough decisions when necessary, but she approaches these moments with poise, ensuring that her team remains focused on the bigger picture and understands the reasoning behind her choices.

In an industry where the pressure to succeed is immense, Vera Wang's ability to maintain grace under pressure has allowed her to rise above the challenges. She has learned how to manage the complexities of her business, stay true to her creative vision, and lead with a sense of calm assurance that has earned her the respect of her peers and the admiration of her clients. For Vera Wang, grace under pressure is not just a personal trait; it is a cornerstone of her success, allowing her to navigate the turbulent waters of the fashion world with elegance and continue to build a brand that is synonymous with luxury, sophistication, and enduring style.

CHAPTER 5: THE VERA WANG AESTHETIC

The Vera Wang aesthetic is a unique blend of timeless elegance, modern sophistication, and unexpected innovation. It's an aesthetic that transcends the boundaries of traditional bridal wear, reshaping the way the world views fashion, particularly wedding gowns. From the moment Vera Wang entered the bridal industry, she set out to create something different, something that broke away from the conventional norms of bridal fashion and allowed women to express their individuality and personal style. What emerged was a look that was as daring as it was refined, characterized by its boldness in simplicity and its ability to combine tradition with modernity.

At the core of the Vera Wang aesthetic is a commitment to luxurious, high-quality materials. Wang's choice of fabrics is always impeccable, from soft silks to delicate chiffons and tulle, each chosen for its ability to drape beautifully and create a sense of movement. Her gowns

are designed to flatter the female form, emphasizing the natural beauty of the wearer rather than hiding it. The fabrics she selects are often sheer or light, giving her designs an ethereal, almost otherworldly quality. This attention to the fabric's texture and its interaction with the body is a hallmark of Wang's work, and it's a key element in defining her aesthetic. The way a fabric flows and moves, how it interacts with light, and the texture it creates against the skin are all central to her design process.

Vera Wang's bridal gowns are perhaps best known for their departure from the traditional white wedding dress. While she still designs in classic whites and ivories, her collections are also filled with rich colors, including blush tones, champagne, and even black. This shift away from the conventional was a daring choice, but it spoke to her desire to offer brides more than just the typical option. Wang's use of color is never ostentatious; rather, it's a subtle shift that adds depth, richness, and dimension to the gown, enhancing the overall feeling of luxury and sophistication. The introduction of

non-traditional shades has become one of the defining features of the Vera Wang aesthetic, and it has allowed her to reach a broader audience, from those seeking a modern twist on tradition to brides looking for something truly unique.

In addition to color, Vera Wang is also renowned for her innovative use of layering and texture. Her gowns often feature multiple layers of tulle, organza, or silk, creating a sense of depth and complexity. This layering can be seen in everything from the voluminous ballgowns that have become a signature of her collection, to the more sleek, modern designs that play with architectural elements. The juxtaposition of soft, romantic layers with structured elements is one of the many ways Wang blends contrasting influences into her creations. It's a balance between softness and strength, tradition and modernity, which makes her aesthetic so compelling.

Another central feature of the Vera Wang aesthetic is her meticulous attention to detail. Each gown is a work of art, with every stitch and embellishment carefully placed

to ensure that the design flows seamlessly. Her use of intricate lacework, delicate beading, and hand-sewn embroidery speaks to her commitment to craftsmanship and artistry. These details are not just decorative; they serve to elevate the entire garment, adding layers of texture and interest that draw the eye. Wang's ability to incorporate elements of couture craftsmanship into her bridal collections is one of the reasons her gowns are considered some of the most coveted in the world.

Her aesthetic also extends to the overall design philosophy. Vera Wang's gowns are known for their ability to tell a story and evoke emotion. They are not just dresses; they are a reflection of the bride herself—her personality, her style, and her desires. Wang's design philosophy centers on creating pieces that resonate with the wearer, allowing them to feel their most beautiful, confident, and authentic. She's built a reputation for designing gowns that feel both contemporary and timeless, offering brides something that will not only look beautiful on their wedding day but will also hold emotional significance for years to come.

Beyond bridal wear, Vera Wang has successfully expanded her aesthetic into other areas of fashion, including evening wear, ready-to-wear collections, and accessories. Her evening gowns maintain the same principles of luxurious fabrics, intricate detailing, and modern elegance, while her ready-to-wear collections are a more relaxed, but still distinctly chic, extension of her vision. The expansion into other areas has allowed Vera Wang to build a cohesive brand that maintains the core elements of her aesthetic, even as it grows and evolves over time.

At the heart of the Vera Wang aesthetic is her ability to redefine tradition. While her designs often draw from classic bridal elements, such as lace and satin, she reinterprets them in fresh, modern ways. Her ability to mix the old with the new—whether through a juxtaposition of a traditional silhouette with an avant-garde twist, or the use of modern colors and materials in classic designs—has made her one of the most influential designers in bridal fashion. This ability

to stay ahead of the curve, while staying true to her core philosophy, is what has helped Vera Wang build an enduring legacy.

The Vera Wang aesthetic also represents a sense of empowerment. By creating designs that emphasize the personal style of the bride, Wang's gowns allow women to feel as though they are wearing something that truly reflects their individuality. Each gown is an expression of beauty and grace, but also strength and independence. Vera Wang's creations encourage women to embrace their own sense of style, to break away from traditional molds, and to wear a gown that makes them feel powerful, beautiful, and confident.

Ultimately, the Vera Wang aesthetic is about more than just the physical appearance of the dress; it is about the experience of wearing it. Her gowns are designed not only to look stunning but also to make the wearer feel a deep, emotional connection with the moment. Through her unique blend of tradition, modernity, craftsmanship, and innovation, Vera Wang has created an aesthetic that

is both timeless and forward-thinking—a reflection of her own personal style and vision, and a standard for bridal fashion that continues to inspire and captivate women around the world.

Fashion and Culture: Vera Wang's Influence

Vera Wang's influence on fashion and culture extends far beyond the bridal industry. As a designer, she has redefined traditional notions of beauty, style, and femininity, becoming a global icon whose work resonates across diverse fields, from celebrity culture to pop culture and even fashion journalism. Wang's unique blend of artistry, innovation, and cultural awareness has left an indelible mark on fashion, influencing not only the way brides dress but also how fashion is perceived in the modern world.

Wang's rise to prominence began with her groundbreaking work in the bridal fashion industry, where she redefined the concept of wedding gowns, but her influence quickly transcended this niche. Her designs are synonymous with luxury, exclusivity, and a deep understanding of modern femininity. Her ability to push the boundaries of traditional bridal wear by experimenting with color, fabric, and design has made her a visionary in a field that was once relatively conservative. In doing so, she has set trends that have influenced wedding fashion globally, encouraging brides to embrace their individuality and personal style rather than adhere to the strict conventions of what a wedding dress "should" be.

One of the ways in which Vera Wang has shaped the culture of bridal fashion is through her deconstruction of traditional design elements. The classic white wedding dress, long associated with purity and formality, was no longer the only acceptable option. Wang introduced a variety of hues into her collections, from pale blush and champagne tones to the boldness of deep reds and

blacks. By doing so, she made a statement that a wedding gown could reflect the personality and desires of the bride, rather than merely conforming to a prescribed cultural ideal. This disruption of tradition challenged the status quo and opened the door for more diversity in how weddings are approached and celebrated, particularly in the context of fashion.

Wang's influence on wedding culture can also be seen in her focus on the emotional and experiential aspects of the bridal journey. She has created an atmosphere in which the wedding gown is not just a dress, but a symbol of the couple's love story and the woman's unique journey to this special moment in her life. In her designs, there is an inherent understanding that fashion is more than just aesthetics—it is a language of expression. Wang's bridal collections are imbued with meaning, whether it's the layers of silk representing layers of emotion or the intricate beadwork that signifies the intricate details of the couple's relationship. This attention to the emotional aspects of fashion has had a profound impact on how people view the role of clothing

in their lives, pushing fashion to become a more personal and expressive part of cultural experiences.

Her influence also stretches into the world of celebrity. Vera Wang's gowns have graced the bodies of some of the most iconic figures in entertainment, from film stars and musicians to athletes and royalty. This celebrity connection has only magnified her cultural influence, as fans and fashion followers closely watch which gown their favorite stars are wearing on the red carpet, or which dress a public figure chooses for their wedding. Wang's ability to design gowns that enhance the personal style of her clients while still pushing the envelope has made her a designer of choice for those who want to make a statement. In the process, she has redefined what it means to be fashionable, showing that elegance doesn't have to be conventional or traditional—it can be bold, modern, and daring.

Vera Wang's cultural impact is not confined to bridal and celebrity fashion alone. Her influence has been felt across the broader fashion landscape, particularly in the

way the public perceives luxury and sophistication. Through her strategic collaborations, she has expanded her brand into ready-to-wear collections, accessories, fragrances, and even home décor. Each of these ventures has reflected her ability to create an immersive aesthetic, one that is instantly recognizable and synonymous with style and luxury. These expansions allowed her to shape the way consumers understand luxury goods, creating an aspirational brand that transcends the wedding day to become part of their everyday lives.

Additionally, Vera Wang has also helped elevate the global conversation around body image and self-expression. Through her work, she has continually advocated for women to embrace their bodies, whatever their shape, size, or appearance may be. Her designs often celebrate the natural form, offering a variety of silhouettes that are flattering for different body types. She's pushed back against narrow standards of beauty and has become a champion of body positivity within the fashion industry. This has had a ripple effect, inspiring other designers and brands to create more inclusive

collections that cater to a broader spectrum of women, further transforming the industry's approach to beauty and style.

Vera Wang's aesthetic, which balances timeless elegance with modern innovation, has had a broader cultural significance in that it represents the idea of reinvention and constant evolution. As the world changes and societal norms shift, Vera Wang's fashion has always been at the forefront of these cultural shifts, reflecting both the desires and attitudes of the moment while maintaining an air of classic luxury. Her work resonates with a generation of women who seek authenticity and creativity, offering them an opportunity to break free from traditional constraints and express their uniqueness through their wedding attire or everyday fashion.

Moreover, Vera Wang's work also highlights the intersection of fashion and culture, where she is able to capture the cultural zeitgeist through her designs. Whether it's the minimalist bridal gowns she created for the 1990s or the extravagant, dramatic dresses for more

recent decades, Wang's creations often align with broader cultural movements. Her designs are reflective of society's shifts in attitude toward love, relationships, and femininity. As societal values and cultural expectations evolve, Wang's fashion has evolved alongside, never stagnant but ever responsive to the world around her.

In the world of fashion, Vera Wang's influence extends beyond just designing clothing. She has helped reshape the conversation around weddings, celebrity, luxury, and beauty, blending personal expression with high fashion. Her creations have empowered brides, artists, and celebrities alike, encouraging them to wear their stories, dreams, and personalities. Vera Wang is more than just a designer—she is a cultural force, shaping the way we approach fashion in all its forms, from the most intimate moments to the grandest celebrations. Through her enduring influence, she continues to inspire new generations to think differently about style, tradition, and the power of fashion.

CONCLUSION

Vera Wang's journey stands as a powerful testament to how grace, discipline, and an unwavering vision can forge an enduring legacy. From her roots in a traditional New York upbringing to her meteoric rise in the fashion world, Wang's life has been marked by an ability to reinvent herself and overcome challenges, whether in the form of professional setbacks, personal adversity, or the ever-changing landscape of fashion itself.

Through each chapter of her career—first as a figure skater, then a Vogue editor, a designer at Ralph Lauren, and finally, as the creator of her own brand—Wang has displayed a tireless commitment to excellence and a dedication to pushing boundaries. She transformed bridal wear from a predictable tradition into a realm of high fashion, breathing life and innovation into a market that had grown static. Her boldness to create bridal and evening wear with both elegance and edge has made her not only a designer but a cultural icon, inspiring

countless designers, brides, and fashion enthusiasts around the world.

Grace Under Pressure reflects on the deeper essence of Wang's journey: the courage to take creative risks, the resilience to overcome doubts, and the vision to inspire others. Her story is more than a biography; it's a reminder of the power of embracing one's passions, evolving with one's art, and staying true to a personal sense of style and purpose. As she continues to expand her brand and influence, Wang's legacy is not only in the gowns she's crafted or the trends she's set, but in the boundaries she's broken and the inspiration she's given to future generations of creators. Vera Wang's life, characterized by elegance, strength, and innovation, truly exemplifies what it means to be a legend in both fashion and grace.

www.ingramcontent.com/pod-product-compliance
Lightning Source LLC
Chambersburg PA
CBHW070423240526
45472CB00020B/1169